D0021909

This little book
of friendship
belongs to

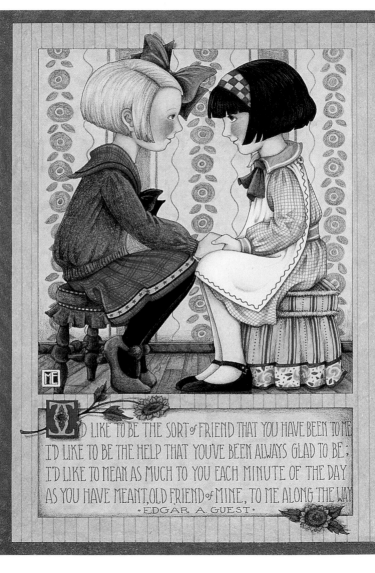

I'D LIKE TO BE THE SORT of FRIEND THAT YOU HAVE BEEN TO ME
I'D LIKE TO BE THE HELP THAT YOU'VE BEEN ALWAYS GLAD TO BE;
I'D LIKE TO MEAN AS MUCH TO YOU EACH MINUTE OF THE DAY
AS YOU HAVE MEANT, OLD FRIEND of MINE, TO ME ALONG THE WAY
· EDGAR A. GUEST ·

Pals

by
Mary Engelbreit

Andrews and McMeel
A Universal Press Syndicate Company
Kansas City

10 9 8 7 6 5 4 3 2

ISBN: 0-8362-4600-4

Library of Congress Catalog Card Number: 91-78258

Pals

It feels so good to have a friend...

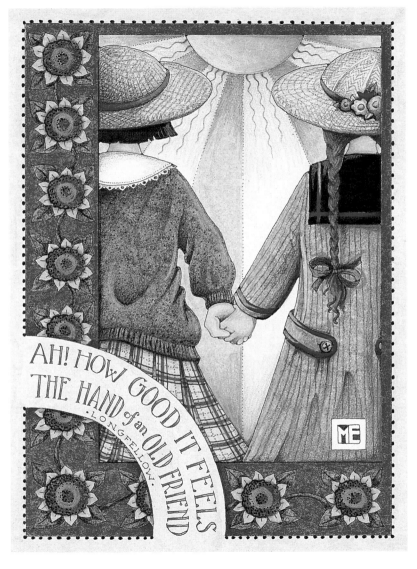

AH! HOW GOOD IT FEELS
THE HAND of an OLD FRIEND
·LONGFELLOW·

one on whom you can depend.

THAT'S WHAT FRIENDS ARE FOR

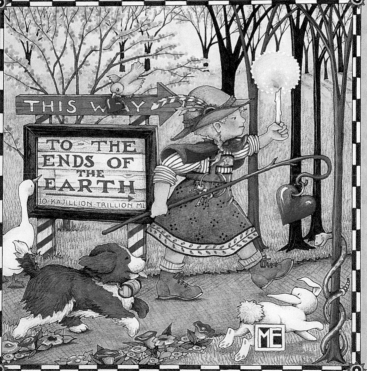

THIS WAY

TO THE
ENDS OF
THE
EARTH

10 KAJILLION TRILLION MI.

ME

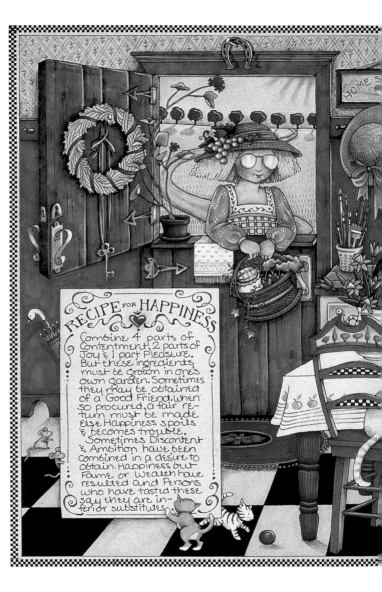

RECIPE FOR HAPPINESS

Combine 4 parts of Contentment, 2 parts of Joy & 1 part Pleasure. But these ingredients must be grown in one's own garden. Sometimes they may be obtained of a Good Friend. When so procured, a fair return must be made Else Happiness spoils & becomes trouble.

Sometimes Discontent & Ambition have been combined in a desire to obtain Happiness but Fame or Wealth have resulted and Persons who have tasted these say they are inferior substitutes.

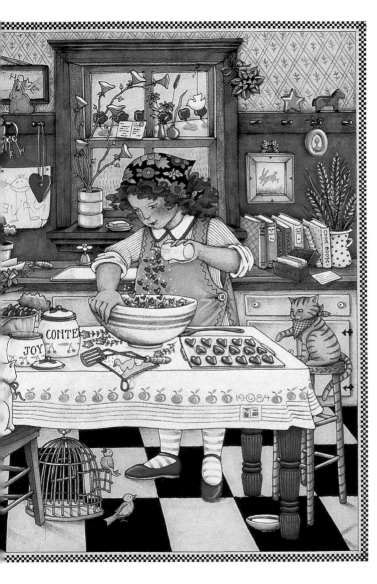

A friend can help
to mend a heart…

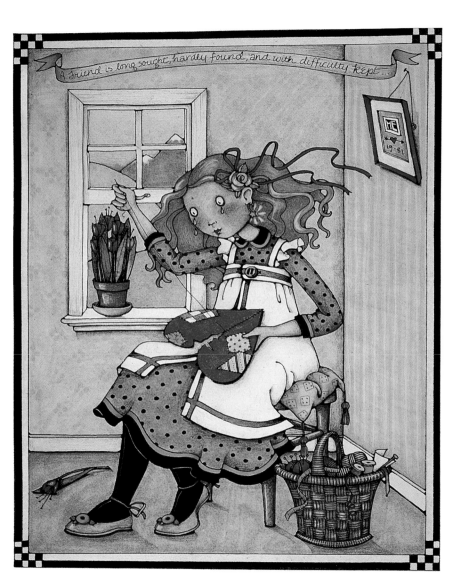

boost you toward
a brand-new start...

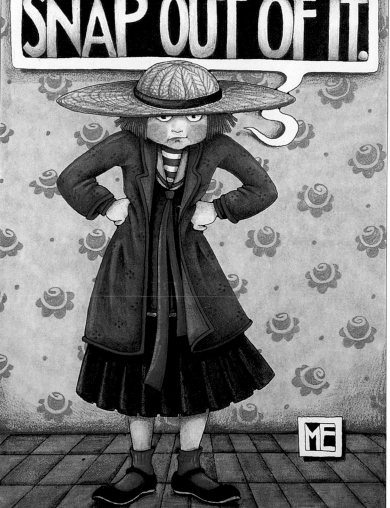

MAKING

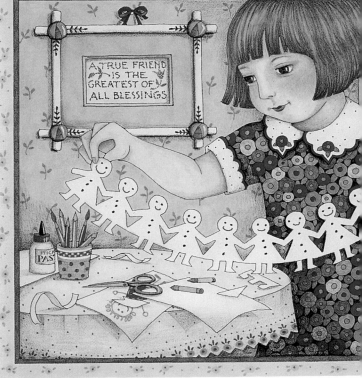

A TRUE FRIEND
IS THE
GREATEST OF
ALL BLESSINGS

STICK
PAS

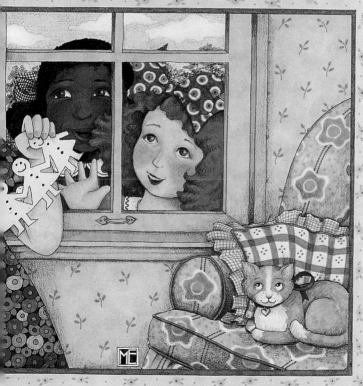

clown with carefree,
schoolgirl glee...

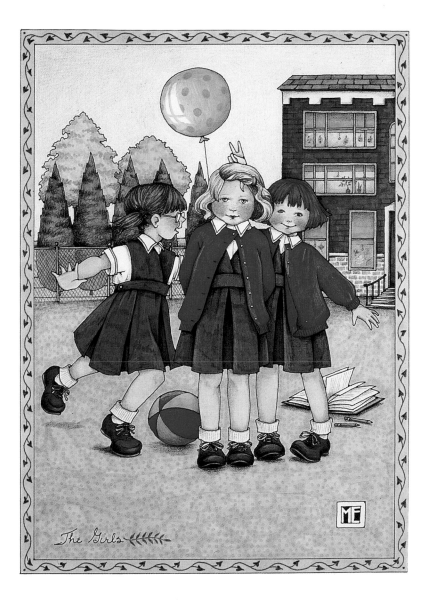

The Girls

share a quiet cup of tea...

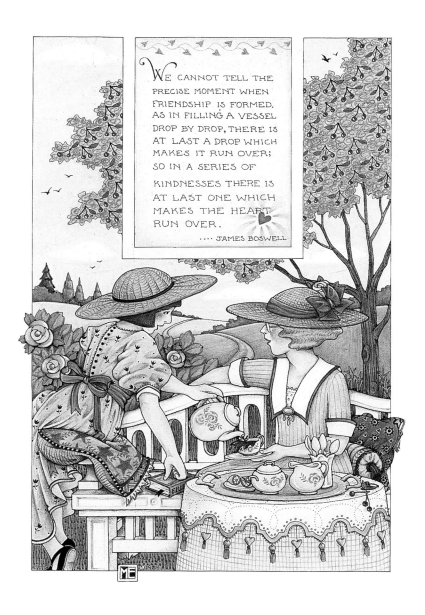

We cannot tell the precise moment when friendship is formed. As in filling a vessel drop by drop, there is at last a drop which makes it run over; so in a series of kindnesses there is at last one which makes the heart run over.

····JAMES BOSWELL

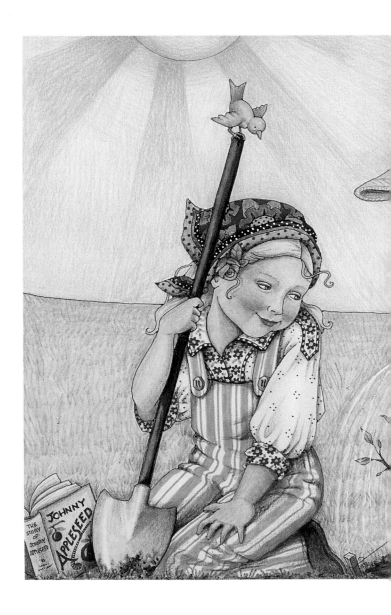

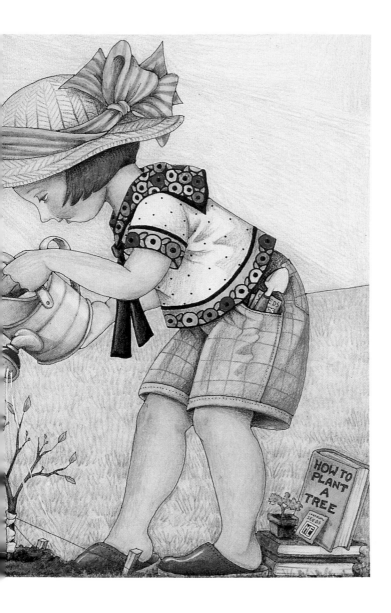

nurture you when you feel low...

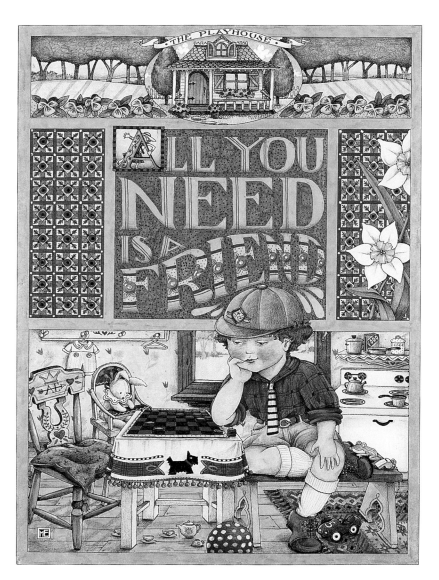

THE PLAYHOUSE

ALL YOU NEED IS A FRIEND

gossip when they're
"in the know"...

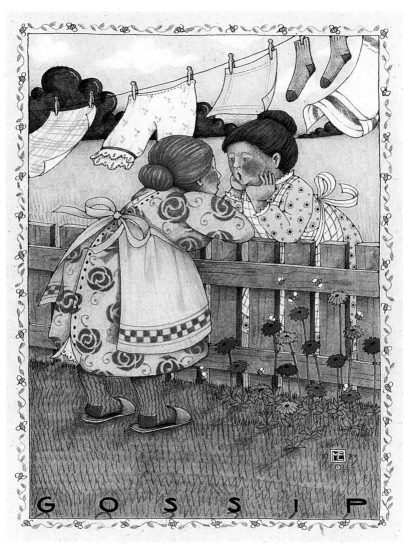

GOSSIP

celebrate the good times, too...

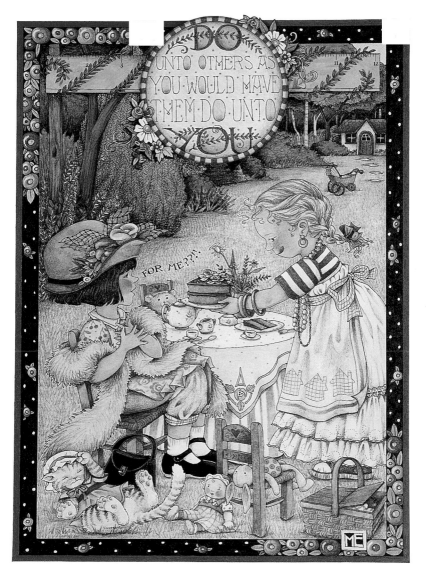

I know because my friend is you.

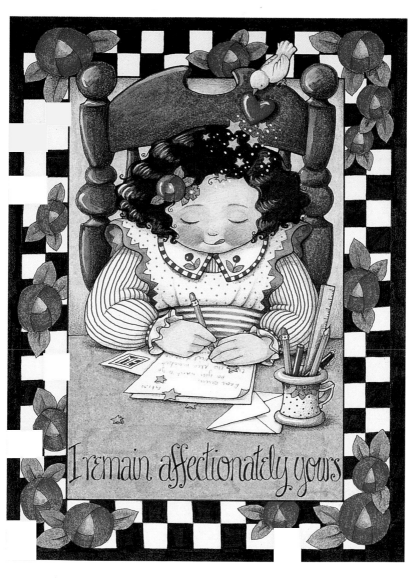

I remain affectionately yours

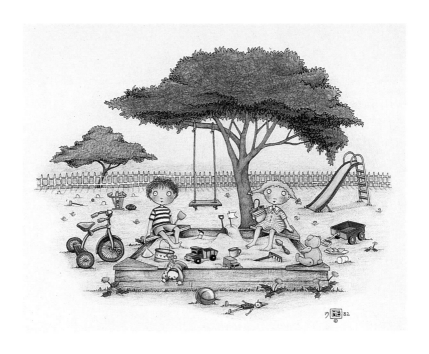

Can you come
over and play?